OCS Visual Storytelling Class 2020

OCS Visual Storytelling Class 2021

CONTENTS

WELCOME TO JUST LIKE YOU

THE VISION FOR THIS PROJECT CAME FROM MAREN JACOBSON, A HIGH SCHOOL STUDENT AND A BURN SURVIVOR. ALL OF THE CREATIVE PIECES IN THE BOOK FROM THE WRITING TO THE PHOTOGRAPHY TO THE GRAPHIC DESIGN AND LAYOUT WERE PRODUCED BY STUDENTS FROM OAKS CHRISTIAN HIGH SCHOOL'S VISUAL STORYTELLING CLASS.

RESEARCH SHOWS THAT THE IMPACT OF A STORY CAN LEAD TO NEW BELIEFS AND NEW BEHAVIORS. SIT BACK, GET COMFORTABLE AND LET THIS BOOK TAKE YOU ON A JOURNEY INTO THE LIVES OF SOME EXTRAORDINARY PEOPLE. WE HOPE YOU WILL BE INSPIRED BY THEIR STORIES!

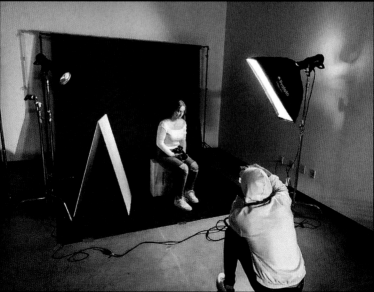

WHEN I FIRST BECAME INTERESTED IN PHOTOGRAPHY, I WOULD NEVER HAVE IMAGINED THE JOURNEY BEFORE ME. MY GOAL HAS ALWAYS BEEN TO USE PHOTOGRAPHY TO MAKE A POSITIVE IMPACT IN THE WORLD. I NEVER IMAGINED I WOULD HAVE TRAVELED TO OVER A DOZEN COUNTRIES DOING PROJECTS FOR OVER TWENTY NONPROFITS IN PLACES LIKE THE AMAZON RIVER, NEPAL, EL SALVADOR, AND AFRICA, BUT THAT IS INDEED WHAT HAPPENED. I NEVER IMAGINED THAT PHOTOGRAPHY WOULD LEAD ME TO BEING ASKED TO DO A TEDX TALK, BUT AFTER PRESENTING THE TEDX TALK ABOUT MY PHOTOGRAPHY JOURNEY, I WAS OFFERED A TEACHING POSITION AT OAKS CHRISTIAN HIGH SCHOOL IN WESTLAKE VILLAGE, CALIFORNIA. I HAD NEVER REALLY THOUGHT ABOUT TEACHING BEFORE. I STILL WANTED TO DO PHOTO ASSIGNMENTS TO HELP THOSE IN NEED AROUND THE WORLD, AND COULD NOT IMAGINE SPENDING MY DAYS TEACHING STUDENTS HOW TO USE A CAMERA. BUT THEN I STARTED TO RETHINK WHAT A TRULY MEANINGFUL PHOTOGRAPHY COURSE COULD LOOK LIKE, AND THEN I GOT EXCITED. WHAT IF I COULD TRAIN TEAMS OF PHOTOGRAPHERS WHO COULD GO OUT AND DO ASSIGNMENTS WITH ME ALL OVER THE WORLD? WHAT IF THESE HIGH SCHOOL STUDENTS COULD REALLY MAKE AN IMPACT IN THE AREAS WE SERVED? WHAT IF SOME OF MY STUDENTS SHARED MY VISION AND WENT ON TO USE THEIR OWN PHOTOGRAPHY FOR GOOD IN THE WORLD? NOW THAT KIND OF TEACHING INTERESTED ME GREATLY, AND TO MY DELIGHT, OAKS CHRISTIAN CAUGHT THE VISION TOO.

THIS PROJECT IS THE PERFECT EXAMPLE OF STUDENTS COMING OUT OF THEIR SHELLS AND STARTING TO THRIVE. IT WAS THE QUIET ASK OF MAREN, A BURN SURVIVOR IN MY CLASS, WHO SPARKED A COLLECTIVE VISION IN OUR DIGITAL STORYTELLING CLASS TO CREATE THIS BOOK. WHEN THE SEED WAS PLANTED, IT STARTED TO GROW. WHEN IT BROKE THROUGH THE GROUND AND SAW DAYLIGHT FOR THE FIRST TIME, FLOWERS STARTED BLOSSOMING LEFT AND RIGHT.

FROM THE WRITING, TO THE POEMS, TO THE GRAPHIC DESIGN, TO THE LAYOUT, AND OF COURSE, THE PHOTOGRAPHY, THIS PROJECT PERFECTLY ILLUSTRATES THE AMAZING TALENT THAT YOUNG ADULTS CAN HAVE WHEN TURNED LOOSE TO EXPLORE THEIR TALENTS AND CREATIVITY, AND USE THEM TO SHINE LIGHT ON WORTHY SUBJECTS. THIS BOOK TOOK TWO YEARS AND A LARGE DOSE OF PERSISTENCE TO COMPLETE IN THE MIDDLE OF A GLOBAL PANDEMIC. THE STUDENTS WHO WORKED ON THIS PROJECT TRULY ROSE TO THE OCCASION TO MAKE SURE THIS WAS COMPLETED, EVEN THOUGH IT HAD TO BE FINISHED VIRTUALLY. THIS HERCULEAN EFFORT BY A GROUP OF HIGH SCHOOL STUDENTS IS SOMETHING THAT I WILL NEVER FORGET. IT HAS BEEN MY GREAT HONOR TO LEAD THIS TEAM.

WHO WOULD NOT WANT TO HELP OUT AND BE INVOLVED IF THEY HEARD ABOUT THE "JUST LIKE YOU" PROJECT? AT LEAST THAT WAS MY THOUGHT WHEN I ASKED SONY IF WE COULD USE THEIR STUDIO AND CAMERA EQUIPMENT FOR THIS PROJECT, AND SURE ENOUGH, THE COMPANY WAS "ALL IN." THANKS SONY! WHEN WE NEEDED AN ICE RINK TO SHOOT ONE OF THE SURVIVORS, AND OUR STATE WAS SHUT DOWN DUE TO THE PANDEMIC, THE LOS ANGELES KINGS STEPPED UP AND LET US USE THE TEAM'S PRACTICE RINK FOR A SHOOT. THANKS LA KINGS!

IT REALLY DOES NOT MATTER IF YOU ARE A HUGE STUDIO, A PROFESSIONAL ATHLETE OR A BURN THRIVER, AS HUMANS WE ARE ALL ON THE SAME TEAM. I BELIEVE THAT WHEN IT COMES RIGHT DOWN TO IT, WE ALL WANT WHAT IS BEST FOR PEOPLE AND WE WANT TO OFFER A HELPING HAND TO THOSE WE MEET ALONG THE WAY. THERE ARE SOME THINGS THAT MIGHT SEPARATE US PHYSICALLY, BUT OUR CALL IS THE SAME. EVEN WITH OUR DIFFERENCES, EVERY PERSON WANTS TO BE SEEN AND TO LET THE WORLD KNOW THAT THEY ARE "JUST LIKE YOU."

David Hessemer

INTRODUCTION

EVER SINCE I WAS TWELVE YEARS OLD, I HAVE BEEN FASCINATED BY THE MAGIC OF PHOTOGRAPHY. AS A BURN SURVIVOR, I UNDERSTAND THE IMPORTANCE OF EXTERIOR AESTHETICS. I DO NOT KNOW WHO I AM WITHOUT MY SCARS, WITHOUT THE LABEL, AND WITHOUT THE EXPERIENCE. BEING A BURN SURVIVOR WILL ALWAYS BE A DEFINING ASPECT OF WHO I AM.

BEING A BURN SURVIVOR FOR NEARLY MY ENTIRE LIFE, I RARELY REFLECT ON WHAT LIFE MIGHT BE LIKE WITHOUT THE SCARS. YES, I AM STARED AT. YES, PEOPLE ASK ME QUESTIONS. YES, I AM BULLIED. I HAVE ALWAYS KNOWN I AM DIFFERENT. I HAVE ALWAYS BEEN DIFFERENT. I AM OKAY WITH BEING DIFFERENT. EVEN THOUGH MY PEERS DID NOT SEE ME AS ONE OF THEM, I SAW MYSELF AS ONE OF THEM. STILL, AS A CHILD I THOUGHT I WAS THE ONLY BURN SURVIVOR IN THE WORLD, UNTIL A PIVOTAL DAY AT GIRL SCOUT CAMP.

IN ELEMENTARY SCHOOL, MY GIRL SCOUT TROOP WENT ON A TRIP TO EARN EXTRA BADGES. AS WE LOOKED FORWARD TO CAMP, WE OVERFLOWED WITH EXCITEMENT. THE THRILL OF THE TRIP FILLED EVERY CONVERSATION. WHEN WE GOT TO CAMP, WE WERE GREETED BY OUR TEENAGE HEROINES—OUR POTENTIAL FUTURE SELVES. HIGH SCHOOLERS ARE GIANTS TO ELEMENTARY SCHOOL CHILDREN. THEY ARE COOLER THAN DISNEY PRINCESSES BECAUSE THEY ARE EXAMPLES OF WHO CHILDREN CAN ACTUALLY BECOME. AS I SCANNED AND EVALUATED THE CAMP LEADERS, MY RADAR FIXATED IMMEDIATELY ON A SCARRED ARM. THE TALL BLONDE TEENAGER HAD A BURN SCAR THAT WRAPPED AROUND HER ARM AND SHOULDER—JUST LIKE MINE. AN OVERWHELMING FEELING OF ACCEPTANCE AND SOLIDARITY FILLED MY HEART, AND I COULD NOT HELP MYSELF. I YELLED OUT TO HER, "I LOOK JUST LIKE YOU!" IT LOOKED THE SAME, FELT THE SAME, AND WAS EVEN IN THE SAME PLACE. I FELT PRIDE AND A SENSE OF BELONGING. I HAD MET SOMEONE JUST LIKE ME. I WAS INSPIRED BY THIS GIRL SCOUT COUNSELOR—IN THE SAME WAY THAT OTHER GIRLS ARE INSPIRED BY PRINCESSES AND FAIRYTALE CHARACTERS.

OVER THE NEXT SEVERAL YEARS, I CONTINUED TO MEET PEOPLE WHO LOOKED LIKE ME THROUGH THE CHILDREN'S BURN FOUNDATION. I WENT TO CAMPS, SUPPORT GROUPS, AND MET LIFELONG FRIENDS. THE CHILDREN'S BURN FOUNDATION TEEN GROUP HAS BECOME LIKE FAMILY TO ME. THIS ORGANIZATION HAS GIVEN ME MORE THAN I CAN DESCRIBE. HOWEVER, MEETING OTHER BURN SURVIVORS AND THEIR FAMILIES AND LEARNING ABOUT THEIR AMAZING LIVES LEFT ME WITH MORE QUESTIONS THAN ANSWERS ABOUT MY COMMUNITY. WHY IS THIS NOT TALKED ABOUT MORE? WHY IS THE BURN COMMUNITY NOT MORE ACKNOWLEDGED? WHY ARE BURN SURVIVORS NOT PUBLICLY RECOGNIZED FOR THEIR STRENGTH, PERSEVERANCE, UNIQUE TALENTS, AND ABILITIES?

ALL THESE QUESTIONS BECAME ANSWERABLE DURING A PHOTOGRAPHY CLASS DURING MY JUNIOR YEAR OF HIGH SCHOOL. EVERY YEAR THE CLASS PICKED A REAL-WORLD PROJECT TO INSPIRE CHANGE. I PROPOSED THAT OUR CLASS CREATE A PHOTOGRAPHY BOOK ABOUT BURN SURVIVORS—A BOOK THAT WOULD BRING AWARENESS AND VISIBILITY TO THE BURN COMMUNITY AND PROVIDE A FORUM FOR OUR STORIES TO BE HEARD.

I WANT THE REST OF THE WORLD TO SEE BURN SURVIVORS LIKE I SEE THEM: AS PEOPLE. NOT AS VICTIMS, SPECTACLES, CHARITY CASES, OR INDIVIDUALS TO BE PITIED. DESPITE OVERCOMING IMMENSE OBSTACLES, WE ARE JUST LIKE YOU. WE HOPE, WE DREAM, WE LAUGH, WE CRY, WE ARE INSECURE, WE ARE PROUD. WE ASPIRE TO BE PART OF LOVING FAMILIES, HAVE SUCCESSFUL CAREERS, AND ENGAGE WITH OUR COMMUNITIES. WE ARE PEOPLE.

LET THIS BOOK—THIS PAGE—BE A REMINDER TO EXAMINE THE WAY YOU SEE OTHER PEOPLE. SEE NOT THEIR EXTERIORS, BUT THE INNATE HUMAN SAMENESS THAT RESTS BENEATH THE SURFACE. ON SOME LEVEL, EVERYONE IS JUST LIKE YOU.

MAREN JACOBSON

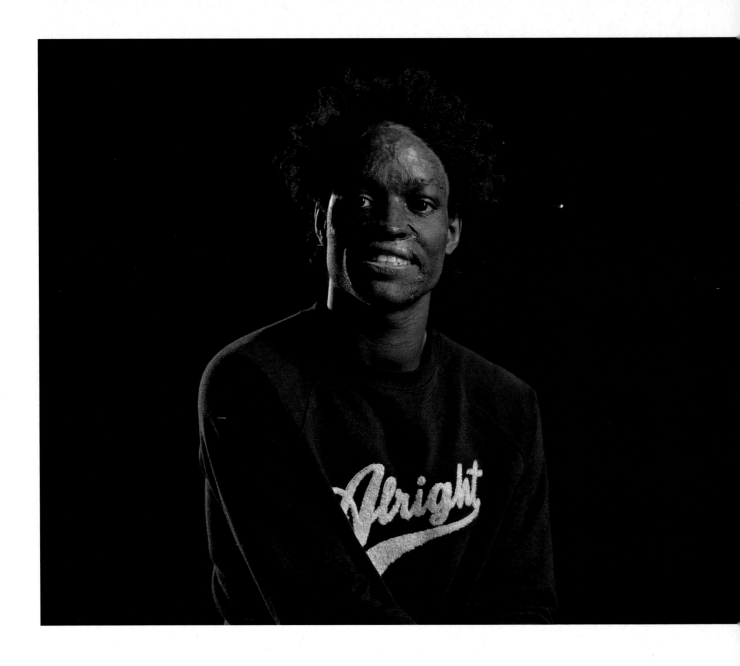

"YOU CAN'T CONTROL THE IMAGE THAT SOMEONE SEES YOU AS;
YOU CAN ONLY CONTROL WHAT YOU THINK OF YOURSELF."

DAMI MOKUOLU

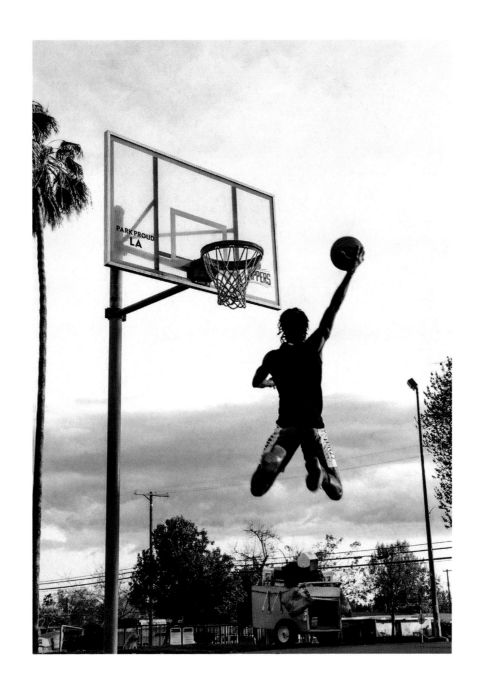

Dami Mokuolu

Within moments of meeting Dami, you know he will do great things. It is an intangible quality that few possess, but from him, it overflows. He was a burn victim but now a burn survivor. He wears his scars proudly and pairs them with a smile. Dami learned to focus on all the things his burns would allow him to do, ensuring that they become gateways, not barricades. He enjoys love and support from his family, and Dami has grown into a compassionate light to this world.

On November 18, 2006, in Port Harcourt, Nigeria, three-year-old Dami wanted to watch TV. A seemingly simple desire, but in Port Harcourt, it meant going outside to turn on a generator in the dark. Lantern in hand, Dami walked toward the generator to help his uncle, when by a twist of fate, he tripped. The gas lantern and generator collided. Fire erupted from the wreckage. Dami's life changed forever.

Burns cover 42 percent of Dami's body. This accident marked a turning point for him and his loving parents, to whom he meant the world. After two weeks of treatment at a pediatric clinic, months of consultation with medical experts throughout Nigeria, he ran out of quality care needed to heal the third-degree burns and bouts of keloids. Dami had the opportunity to come to Los Angeles, thanks to kind-hearted well-wishers. In Los Angeles, with the support of the Children's Burn Foundation, he received the treatment he needed for both body and soul.

WANDERING EYES AND UNCOMFORTABLE GLANCES MADE GROWING UP A DIFFICULT TASK. JUST AS DAMI'S BURNS OUTWARDLY ISOLATED HIM, HE COVERED HIMSELF IN EMOTIONAL MASKS TO AVOID THE TRUTH OF HIS DIFFERENCE. HIS LOVE OF BASKETBALL FLOURISHED, AND THE REST OF HIS LIFE DID AS WELL. DAMI LEARNED TO LOVE HIS UNIQUENESS AND MET OTHER PEOPLE WHO DID TOO. FEW PEOPLE ARE AS CONCERNED WITH THE SUCCESS AND WELL-BEING OF OTHERS AS DAMI. THROUGH THIS TRAGEDY HE GAINED KINDNESS AND STRENGTH THAT RADIATES THROUGH A ROOM, AND HIS PASSION FOR BASKETBALL INSPIRES EVEN THE MOST UNSPORTING PEOPLE.

EVEN THOUGH DAMI HAS EXPERIENCED A TRAUMATIC PAST THAT MOST COULD NEVER IMAGINE, HE LOOKS INTO THE FUTURE, JUST LIKE ANY OTHER TEENAGER. DAMI UNDERSTANDS THE WORLD IS FULL OF OPPORTUNITY, AND HE HAS THE COURAGE TO GRASP IT. HIS DREAM IS TO BE IN THE NBA, ATTEND COLLEGE DEBT-FREE, AND SUBSEQUENTLY BECOME A FASHION MODEL, ENTREPRENEUR, AND MOTIVATIONAL SPEAKER. HIS FAVORITE HOLIDAY IS THANKSGIVING. HE HAS ASPIRATIONS; HE IS JUST LIKE YOU.

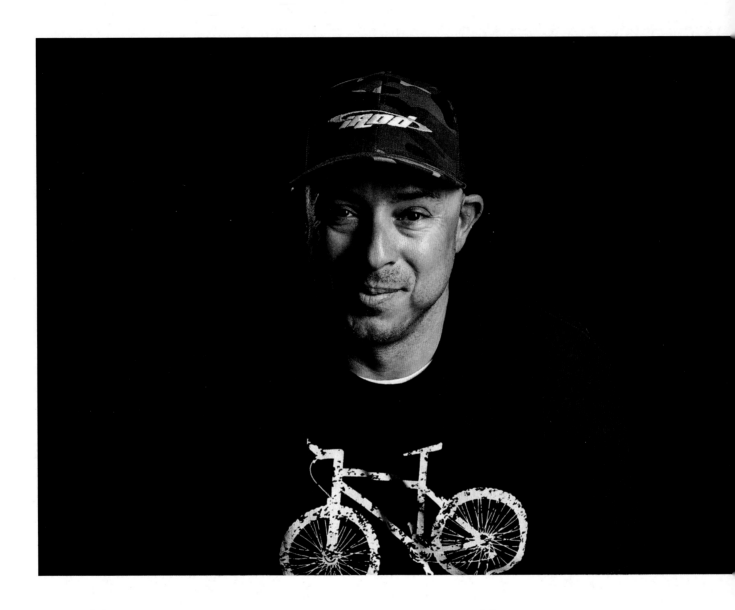

"TRY TO FIND THE BEST IN EVERYTHING. YOU ONLY LIVE ONCE
SO YOU HAVE TO ENJOY EACH DAY AS MUCH AS POSSIBLE."

JOSE FERNANDEZ

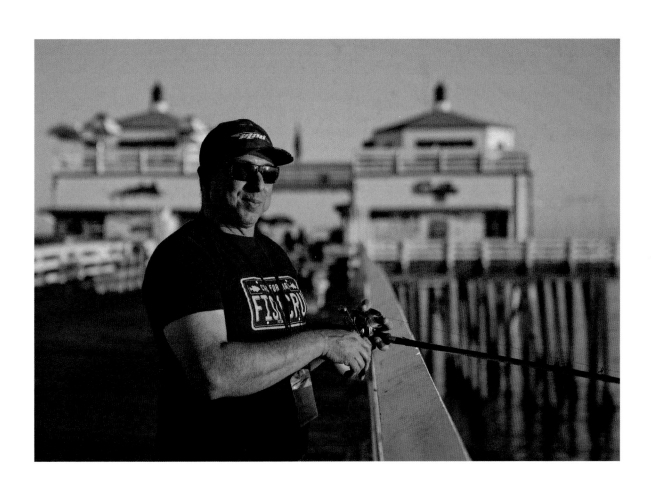

JOSE FERNANDEZ

To most non-burn survivors, shorts are just an item of clothing, but to Jose they represent confidence. In December of 2018, Jose was using a weed eater near his garage. Unbeknownst to him, this simple chore would change the course of his life. A spark from the weed eater flew into the garage and ignited a leaky propane tank leaving Jose burned on 29 percent of his body.

For nineteen days, Jose sat in a hospital bed contemplating his accident. He did not know why or how he survived. As an avid fisherman, hiker, and mountain biker, these burns kept Jose from his hobbies. During the six months it took Jose to get back on a bike, he went through intense, painful treatments. He hid his scars from the world. He searched for a silver lining.

He found this sparkle in his best friend, Fernando, and his girlfriend, Sherry. They helped Jose grieve the life he thought he would lead and accept the brighter one in front of him. Ultimately, Fernando and Sherry helped Jose come to the conclusions that perhaps he had a bigger or better purpose to fulfill in the world.

Finally, Jose was able to rekindle his love for the outdoors. On a fishing trip with several of his close friends, Jose caught a two-hundred-pound fish. This monumental achievement heightened his love for the sport tenfold—every moment at work was a step closer to his next trip. After pulling strength from his family, best friend, and girlfriend, Jose wears shorts again. He has confidence. Although his legs are scarred, he presents them just as proudly as he does his fishing exploits.

DESPITE THE EMOTIONAL AND PHYSICAL PAIN INVOLVED WITH BEIN
A BURN SURVIVOR, JOSE WOULD NOT CHANGE ONE THING ABOUT HIMSEL
HE LOVES THE OUTDOORS AS HE DID BEFORE, BUT WITH A NEWFOUN
PASSION. HE LOVES HIS FRIENDS AND FAMILY AS HE DID BEFORE, BUT WIT
A NEWFOUND KNOWLEDGE OF THEIR SUPPORT. HE LOVES WEARIN
SHORTS, BUT HE LOVES HIS SCARS MORE.

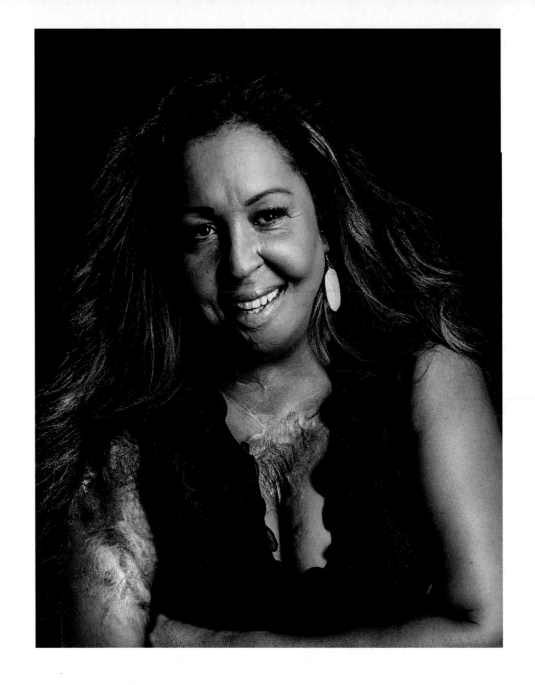

"I CANNOT HIDE MY SCARS,
SO I DO NOT NEED TO HIDE THE REST OF ME EITHER."

YOLONDA HAWKINS

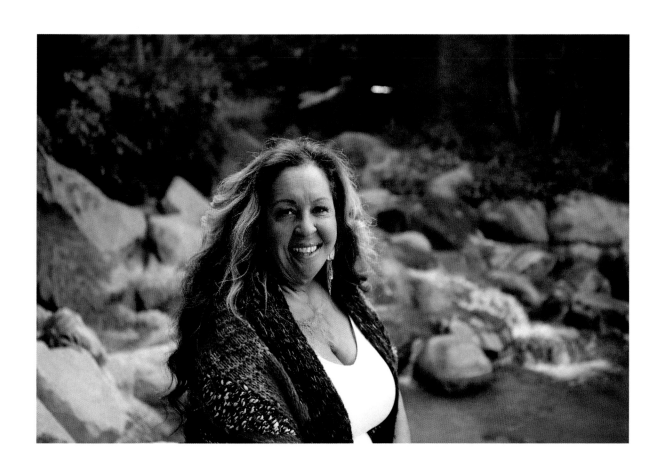

Yolonda Hawkins

Yolonda is a true inspiration to the world. When she was nearly four years old, in September 1974, a grease fire started while Yolonda's mother was tending to her younger sister. Because there was debris outside the kitchen window, Yolonda's mother was forced to take the billowing pan through the living room to the backyard door.

At that same moment, Yolonda was walking through the back door, and the breeze fanned bits of their ignited dinner onto Yolonda's nylon turtleneck. The plastic-based fabric melted into her skin, and when her mother ripped off the flaming sweater, she ripped off Yolonda's skin as well.

For the next eleven years, Yolonda underwent thirty to forty surgeries that varied from skin grafts to skin releases. Yolonda learned the hard way that her burns do not dictate what she could or could not do, and now she has dedicated her life to making sure other burn survivors know this too. Yolonda has loving friends, she has meaningful relationships, and she fulfilled her life-long dream of having a child, in 2014. Yolonda is just like you.

"It is not the end of the world: you can have a life, you can have friends, you can be married, you can have relationships, and you can have children—just like anybody else."

Yolonda Hawkins

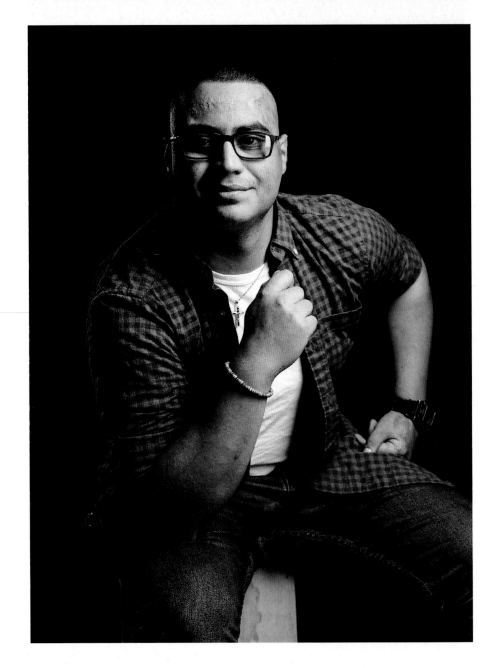

"IF YOU WANT TO DO SOMETHING,
WHAT DO YOU HAVE TO LOSE?"

WALTER GOMEZ

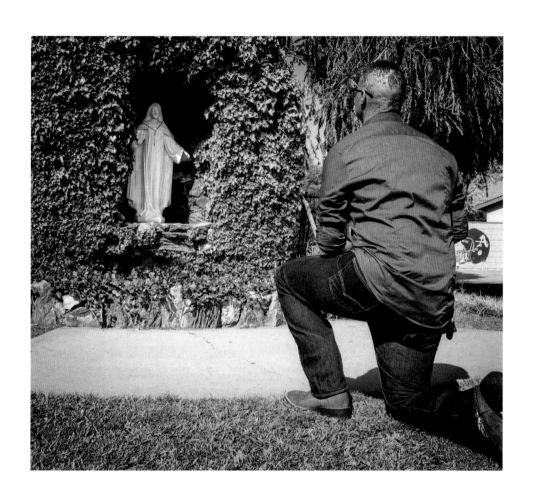

WALTER GOMEZ

In 2004, Walter, his sister, his father, and his mother were in a car accident on the 710 Freeway. The driver was inebriated and was using his phone when he rear-ended Walter and his family. Walter's family's car went off the freeway, rolled, flipped twice, and erupted in flames.

Walter's sister was the only one who made it out of the car unscathed physically. Walter endured a two-week hospital stay to recover from smoke inhalation and was then transferred to a burn center where he spent three months undergoing fifteen major reconstructive surgeries on his back, right shoulder, hands, face, and scalp.

Despite this horrific experience, Walter is proud of his burns and the person they have made him become. His greatest passion is helping others, and this life of service helped Walter realize that people's opinions do not matter and that he can be anyone he wants to be.

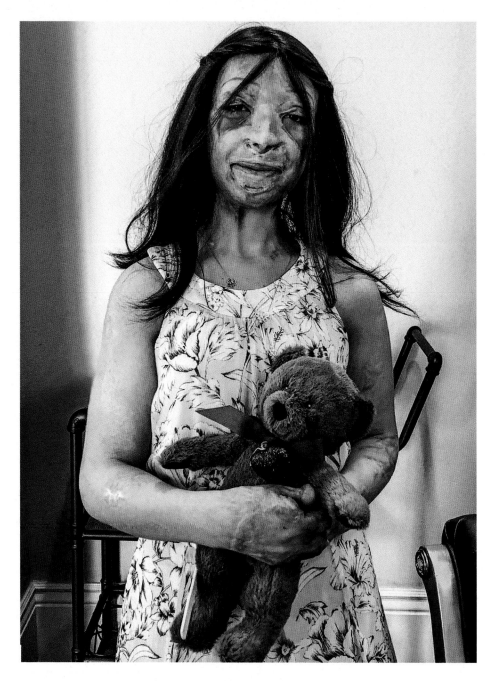

"LIFE IS NOT EASY,
AND NOTHING COMES WITHOUT A PRICE TAG."

MANAL HINDAWI

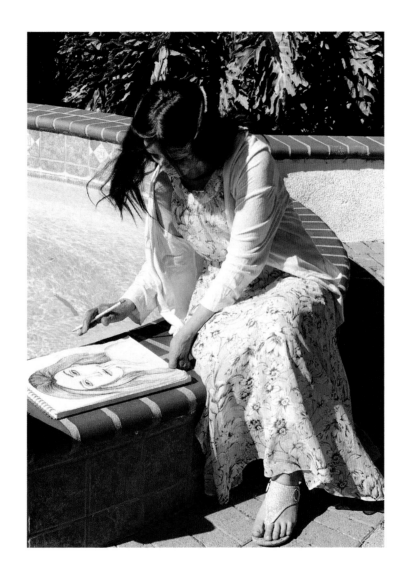

Imagine that the only world, the only life you have ever known is suddenly and irrevocably destroyed. Manal had to do more than imagine this, she had to live it. When Manal was nine years old, a bomb hit her home in Syria. The next thing Manal remembers is sitting in a hospital room, feeling scared and confused. The hospital did not ease her distress: in Syrian culture, those who look different from the rest are hidden instead of celebrated or helped. Manal was isolated, kept from school, and obscured from the world. Her doctors treated only the absolute necessities. They tried to do more, but the medical technology could not support the extremity of Manal's burns. Her family were the only ones endeavoring to help her.

Eventually, Manal and her mother came to the United States. The extreme contrast between the suppression of Syrian culture and the openness of America shocked Manal to her core. Manal could go to school again, she could make new friends, she could be treated as a person instead of as an "other." Manal also learned to use art as a way to express herself. Over the past several years, Manal has honed her skills in drawing and poetry. The hand that was once scarred and immobile now crafts beautiful expressions of sentiment. Manal woke up to find the only world, the only life she has ever known, suddenly and irrevocably destroyed, and she has built a beautiful new one in its place.

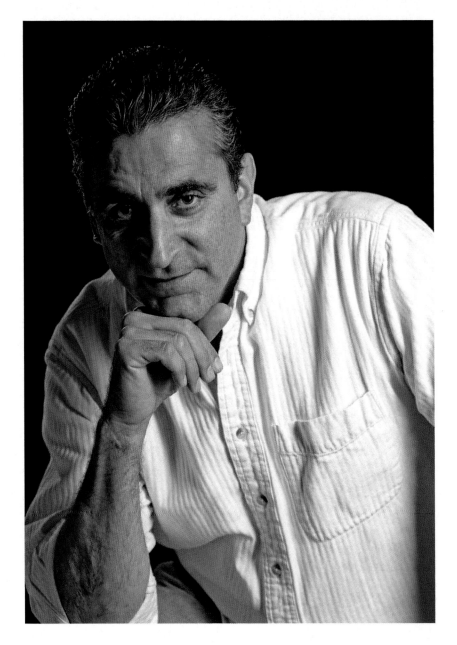

"THE ROAD THAT YOU DESIRE TO TAKE IS NOT
THE ONE THAT YOU ARE DESTINED TO TAKE."

JUAN AZCARATE

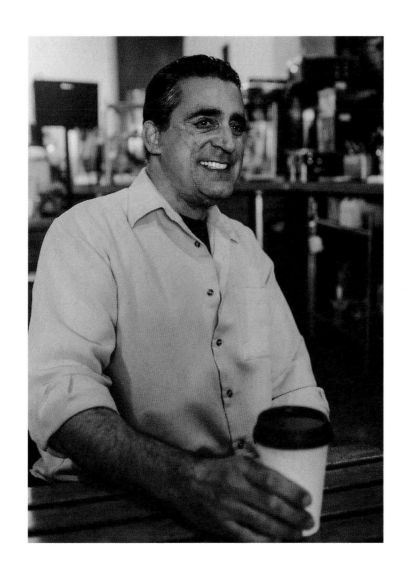

Juan Azcarate

Juan was studying to be a doctor, when on September 8, 1984 his car broke down on the 405 freeway. As anyone would, he pulled over and looked under the hood. A passing 19-year-old drunk driver fell asleep at the wheel and sideswiped Juan's stalled car. On impact, the other driver's car exploded, then ran him over. Juan ended up under the other driver's car with battery acid, hot radiator fluid and oil pouring over his right face, eye, chest and arms, causing 3rd degree burns. The impact caused internal bleeding in his abdomen and lungs, broke his right leg, knee, pelvis, hip, ribs, wrist and shoulder.

Over the next three years, Juan had twenty-two surgeries, primarily orthopedic but some cosmetic reconstruction to his right eye, face and arms. After leaving the hospital, Juan experienced extreme depression. The life Juan thought he wanted was ruined because of someone else's negligence. However, Juan decided to forgive the drunk 19-year-old; Juan decided that his own happiness is worth more than his grudge. As a result of Juan's radical forgiveness, he graduated from college, he learned the value of helping, others, and he brought a beautiful daughter into the world. Juan is now a burn thriver.

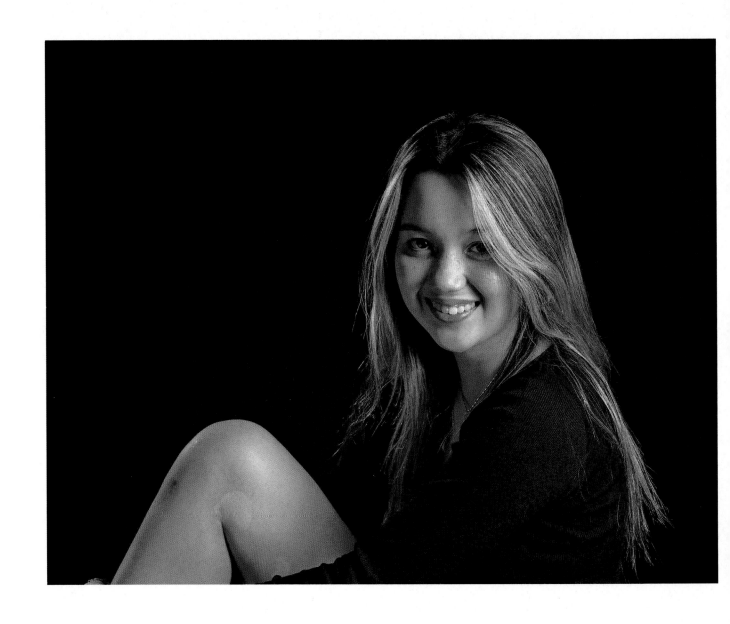

"WHAT MATTERS IS WHAT'S INSIDE; YOU WILL FIND YOUR PEOPLE."

MADISON KAMALI

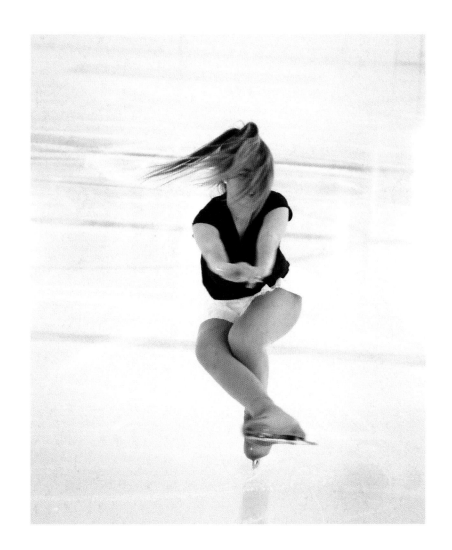

Madison Kamali

At eight years old, Madison was more determined and passionate than those twice her age. She figure-skated for hours every day, golfed as a hobby, and spent time with her friends whenever she had a free moment.

It is clear that Madison had a bright future in front of her as an Olympic ice skater, shrewd negotiator over golf games, and a loving friend. Then on May 24, 2008 her future became unknown.

After a skating lesson, Madison was making Udon noodle soup with her grandfather. The bowl of blistering hot soup spilled into her lap and left large scars on both of her thighs. Before accepting the severity of her burns, Madison showed tremendous fortitude. She tried to find home remedies for her pain; she even went to her next skating lesson in the hopes that the ice would chill her burns. Then she made an even braver decision: she asked for help.

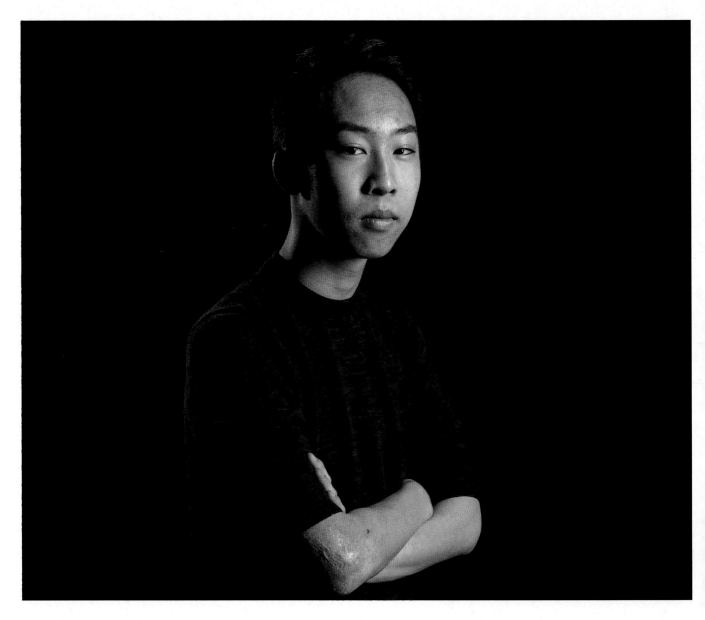

"BEING DIFFERENT, BEING THE ONE THAT STANDS OUT, IS NOT A BAD THING; IT IS NOT SOMETHING TO LOOK DOWN UPON; IT IS JUST TO SHOW THAT YOU ARE STRONGER."

JORDAN WOO

Jordan Woo

It is difficult to know who you are, when you have never faced adversity. Jordan learned about his true nature in light of steep trials. On May 30, 2015, fourteen-year-old Jordan unsuspectingly joined his mother and father for a pancake breakfast at his sister's school. One of Jordan's great passions in life is food, and as he handed his plate over the buffet table to the server, he was not greeted by pancakes, but by a fireball of overheated cooking spray and propane.

Screams of agony filled the multipurpose room, and Jordan embarked on his journey to recovery. Although he was 100 percent functional, 10 percent of his body was burned. He spent ten days in the hospital undergoing surgery after surgery, but it did not feel like ten days. Fun games and services provided by a Burn Center distracted Jordan from his imminent struggle.

Jordan then spent his summer vacation preparing himself for school. He underwent surgeries for blisters, burned tissue removal, and scar minimization. The experience can only be described as painful. Although he overcame the physical pain, Jordan was unprepared for the emotional pain that arrived the first day of school. Self-consciousness swept over him as he used long sleeves and pants to shield himself from lingering glares and attention. Even though his physical scars were completely covered, his emotional scars were as raw as ever.

But after all this, Jordan would not change a thing. If there was a magic button that meant he did not go to that pancake breakfast, he would not press it.

Out of all this awfulness, he emerged stronger, more empathetic, and more generous than he knew he was capable of. His loneliness reignited a passion for aviation. His pain inspired him to help others heal.

In times of loneliness, Jordan turns his mind to the sky. When he was a child, Jordan's father bought him a present. Instead of opening the package to find a toy truck, Jordan found an interactive globe. Over the next few months, Jordan and his father memorized every country in the world, and a secret yearning to visit them emerged. So, when reality is too harsh, Jordan visits one of his many castles above.

Before May 30, 2015, Jordan was just a normal, introverted kid, and he enjoyed his anonymity. But after this date, Jordan emerged a wonderfully different person who is proud of his passions, proud of his impact, proud of himself.

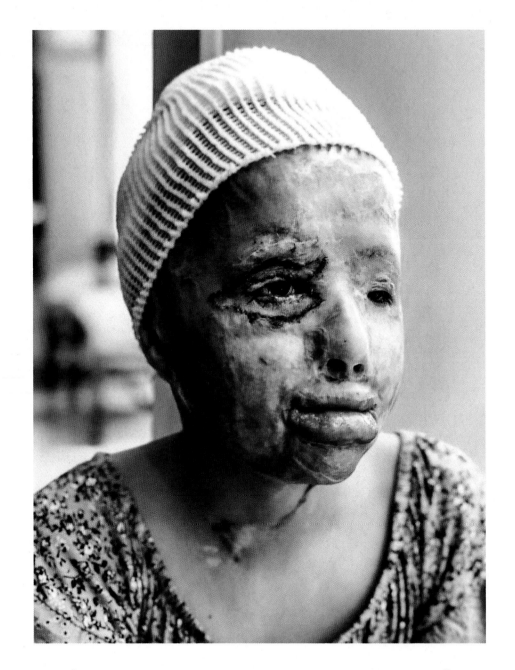

"EVERY DAY IS AN ADVENTURE FOR ME."

AYSHA AL SALOOM

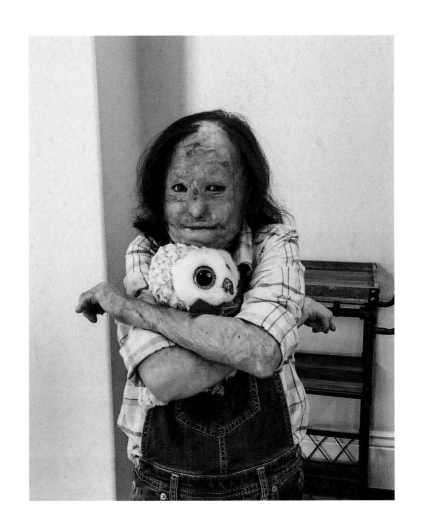

Aysha Al Saloom

Aysha's biggest passion in life is to make others happy. The joy that radiates from within her is so potent, so pure. She likes to draw things that make others happy, she likes to dance and she likes the happiness of holidays. Aysha truly is a happy light in a dark world—a dark world that she has experienced.

Aysha was burned during a bombing in Syria when she was only five years old. When the bomb landed on her house, it ignited the furnace in her nursery, and Aysha along with it. She has burns on 80 percent of her body, including her hands and face. Aysha's family sought medical attention in Turkey, but ultimately, they could not give her the attention she needed. Aysha and her mother came to the United States to receive help from Children's Burn Foundation. Instead of meeting the judgment she so feared, Aysha was embraced with open arms upon arrival.

Even though she lives away from her five siblings, even though she looks different, even though she was burned, Aysha would still rather endure all the struggle that led her to this point in her life than flip a switch and endure none of it. The struggle made Aysha stronger, smarter, kinder, and happier. The struggle is what taught Aysha to be a happy light in a sometimes dark world.

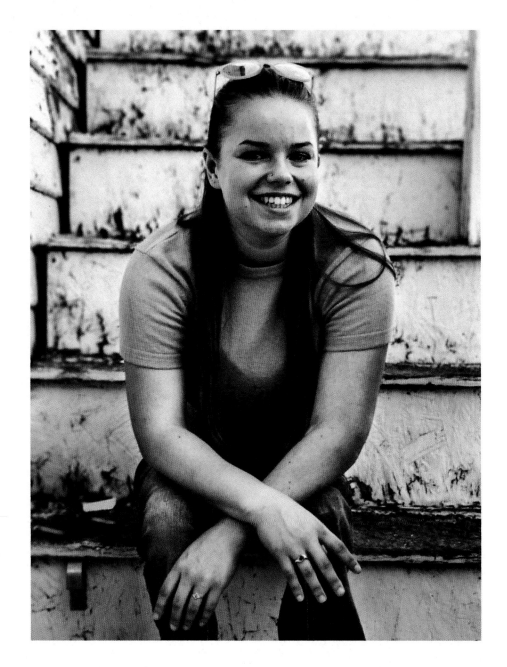

"You're different - so be it."

Megan mckeon

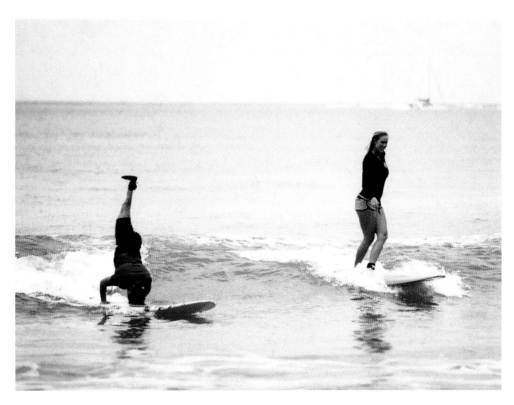

Megan catching a wave on her head with Bethany Hamilton

MEGAN MCKEON

ADAPTATIONS ARE SOMETHING WE LEARN ABOUT IN BIOLOGY CLASS. THEY ARE SLIGHT CHANGES IN GENETIC TRAITS THAT HAPPEN OVER GENERATIONS AND GENERATIONS. THE ONE RULE OF ADAPTATIONS IS THAT THEY DO NOT OCCUR BECAUSE OF THE INDIVIDUAL'S WILL—THEY ARE GENETIC DISCREPANCIES THAT PERSIST BECAUSE THEY ARE HELPFUL. MEGAN DID NOT HAVE THE LUXURY OF FOLLOWING THE RULES OF BIOLOGY. MEGAN HAD TO DO WHAT NO LIVING ORGANISM HAD DONE BEFORE—ADAPT AS AN INDIVIDUAL.

WHEN MEGAN WAS ONLY FIVE MONTHS OLD, HER BIRTHMOTHER DROPPED A CIGARETTE IN HER CRIB AND LEFT HER TO BURN FOR HOURS. SHE HAS BURNS OVER 50 PERCENT OF HER BODY, RANGING FROM SECOND TO FOURTH DEGREE. IN LATVIA, WHERE MEGAN SPENT HER FIRST YEAR, THE MEDICAL RESOURCES ARE ABYSMAL, AND WHEN AN INJURED INFANT APPEARS AT THE HOSPITAL'S DOORSTEP, SHE IS USED AS A MEDICAL EXPERIMENT INSTEAD OF TREATED AS A PATIENT. MEGAN HAD TWENTY-THREE SURGERIES WITHOUT ANESTHESIA, ONE OF WHICH RESULTED IN LOSING HER LEFT LEG.

THE HORRIFIC CIRCUMSTANCES OF MEGAN'S EARLY CHILDHOOD SOON MADE IT TO A MAGAZINE ARTICLE, AND FORTUNATELY THE RIGHT PERSON READ IT. SUSAN MCKEON SAW THIS ARTICLE AND INSTANTLY FELT A CONNECTION. HER PURE AND FULL HEART WENT OUT TO THE UNLUCKY INFANT, BUT THE EXTREMITY OF MEGAN'S SITUATION GAVE HER PAUSE. WHEN SHE GOT HOME, SUSAN TOLD HER HUSBAND, MARK, MEGAN'S STORY. OVER THE NEXT SEVERAL MONTHS, THE COUPLE TOOK NO ACTION BUT HELD MEGAN IN THEIR HEARTS. ON CHRISTMAS EVE ALL THIS BRIMMING LOVE CULMINATED INTO A TRIP TO VISIT THE DESTITUTE LATVIAN INFANT. THE MOMENT MEGAN'S MANGLED LEG, RAW SKIN, AND RADIANT SMILE CAUGHT SUSAN AND MARK'S EYES, THEY NO LONGER SAW THE INFANT FROM THE ARTICLE, THEY SAW THEIR DAUGHTER.

MEGAN'S STORY DOES NOT END HERE, HER STORY IS NOT THAT SHE ENDURED AN ARDUOUS BEGINNING AND WAS SAVED ONLY BY THE KINDNESS OF OTHERS. THIS DOES NOT DIMINISH THE AMAZING AND SELFLESS ACTION OF THE MCKEONS, BUT MEGAN TOOK CONTROL OF HER OWN STORY—SHE WILLED HERSELF TO ADAPT.

FROM BEING IN MOVIES, TO TRAVELING, TO PUBLIC SPEAKING, MEGAN DOES NOT LET HER SECOND CHANCE WITHER. SHE PLAYS THE SAME GAME OF BASKETBALL, DOES THE SAME GYMNASTICS, SKIS DOWN THE SAME SLOPES, AND SURFS THE SAME WAVES AS ANY TWO-LEGGED INDIVIDUAL. MEGAN LITERALLY TURNS THE WORLD UPSIDE DOWN, AND SURFS ON HER HEAD! INSTEAD OF LETTING HER BURNS DEFEAT HER—INSTEAD OF GIVING HER INSECURITIES AND DIFFERENT ABILITIES THE POWER TO CONTROL HER—MEGAN TAKES CHARGE OF HER OWN LIFE AND DOES ALL THE THINGS SHE WANTS TO DO. MEGAN DOES THINGS "THE MEGAN WAY," AND WHAT BETTER WAY IS THERE?

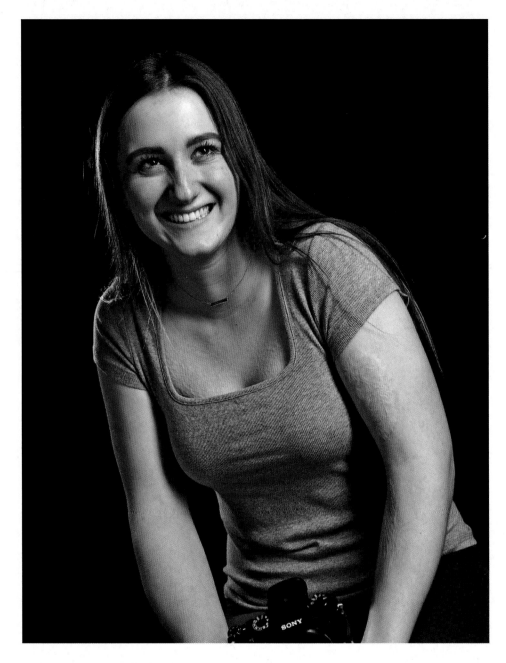

"One bad thing doesn't consume or define you."

Maren Jacobson

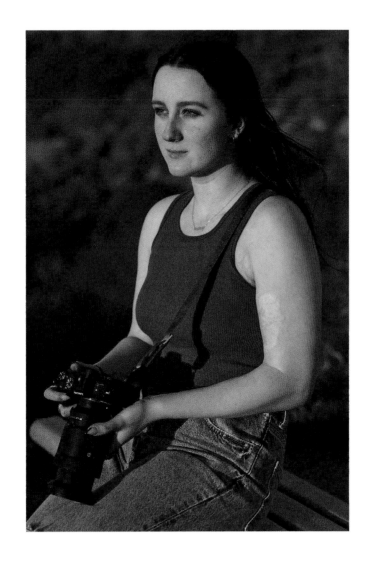

When Maren was two years old, she wanted to make macaroni and cheese with her dad. In a pivotal moment, she accidentally poured an entire pot of boiling water onto herself. She was burned on 40 percent of her body, including her head, face, hands, arms, torso, and legs.

The three weeks of treatment that followed included many painful surgeries, complications and an infection diagnosis that nearly killed her. Even today, Maren still receives laser treatments on her chin.

Once Maren miraculously survived her physical injuries, she began to tend to her emotional injuries. She was insecure about her scars, and she tried to cover them up with long sleeves and pants.

Maren overcame these scars by discovering her passion for photography. Photography provided her with a creative outlet, something to get excited about and look forward to.

Most importantly, photography helped Maren find purpose. Now, her goal is to increase the representation of minority populations—like burn survivors—in the media. Instead of allowing her burns to be the master of her life, Maren uses them to serve others and herself.

Pictures and Words

They say a picture is worth a thousand words, but this does not mean that words are meaningless. Words can shape the way we look at the picture, they shape the way we look at the world, and they shape the way we look at life. Perspective, connection, transformation, empowerment, and unity all conjure pretty pictures, but in a uniform line they contrive a whole new meaning. They embody "just like you." Words are a way we express ourselves. The flow, the order, the syntax, and the emphasis are all indicators of who we are. Even though we all use the same words, they hold unique meanings to every individual. Much like abstract art, when one person looks at a Picasso, that person is left with hope and encouragement. The next person could be filled with sorrow and confusion, but, when a person looks at a word as a vital organ of a larger story, it loses its abstraction and becomes a vessel of truth. Perspective, connection, transformation, empowerment, and unity are the vessels of truth that proclaim that burn survivors are just like you.

Humanity is drawn to images. Little kids read picture books, adults thumb through magazines, and the elderly peruse the photographic evidence of their youth. Social media is saturated with photography. Just as words tell and prove that burn survivors are "just like you" simply because they are different, photographs show you in plain terms. In terms of impression, pictures are the inverse of words. When we read a passage, we understand its meaning. However, when we see just one word, each is personally subjective. When we see a single picture, there is only one universal truth that can be derived. However, the contextual application varies. Everyone sees the same freckle, the same feature, the same scar, and then derives a unique message.

DO NOT LOOK AT THESE PICTURES ▮▮D SEE VICTIMS, SUBJECTS OF PITY OR SCORN ▮ SEE PEOPLE. SEE MOTHER▮ ▮FATHERS, DAUGHTERS, SONS, SISTERS, BROTHERS, AND MOST OF ALL, THRIVERS.

WORDS ALONE ARE MEANINGFUL. IMAGES ALONE ARE ALSO MEANINGFUL. WHEN BROUGHT TOGETHER HOWEVER, THEY CREATE A SYMPHONY OF HUMAN EFFORT. THEY STRIKE CHORDS SO POWERFUL THAT THE REVERBERATION REACHES ALL CORNERS OF THE HEART. THIS IS HOW CHANGE IS MADE.

Empower

The struggles of another often lie in solitude,

But the light of a stranger is bright.

Their differences—no longer misconstrued!

Past hardships provoke a collective fight.

PERSPECTIVE

TIVITY OF PERSPECTIVE CHANGES WITH THE WIND.

QUALL OF PREJUDICE CLOUDS ONE'S VISION.

USH OF CLARITY CLEARS ONE'S CONSCIENCE.

AFTER THE STORM, FRESH HOPE DAWNS

WEATHERING DARK SKIES AWAY,

AND LOOK, A NEW DAY!

Connect

Detached by our differences.

Attached by what we endure.

Perpetual chains link us all

And in this unity we are secure.

UNITY

The cries of many reverberate,

Like roaring thunder in a canyon.

This deafening echo can reach the ends of the Earth,

Once everyone becomes a companion.

TINY SEEDS, IGNORANT OF THE WIDE WORLD'S REACH.

UNDERGROUND THEY SIT, UNAWARE OF THE MOON AND SUN.

ONLY ONCE THEY RECEIVE NOURISHMENTS ENOUGH TO BREACH

DO THEY COME TO KNOW THEIR SIZE,

THE SUBLIME CHARM OF REALITY

AND WHAT LIES BEYOND SUNRISE.

Humanity desires nothing more than a place to belong—a place to feel known. In essence, every individual wants to feel "just like you." To truly understand the meaning of this phrase, we must first dissect and define it. The word "just" is an adverb. Adverbs modify the ways we interact with people. You can speak quietly, and you can speak gregariously. Both are the same action, but the modifier gives the verb a new meaning. In the context of this phrase, the word "just" is imploring the world to modify the way they interact with other people—it implores the world to treat others justly. To treat others justly is to be kind, compassionate, and courageous in the face of injustice. Justice is simply following the golden rule: treat others the way you would like to be treated. In addition, "like" is a preposition—a word that sets up a time and space relationship. This word gives the world a reason to act justly. Individuals participate in the same time and space relationship as those around them. If we are all dealing with the same universe, why would we not want to act justly toward our fellow man? Finally, the word "you" shifts the focus from internal contemplation to external expression. So "just like you" is really defined as acting with justice toward those around you because we all want the same things.

People who look different, or act different, or think different are also "just like you." They are "just like you" because they are different. There are hundreds of clichés that emphasize the point that every individual is unique—people are like snowflakes, life is like a box of chocolates, and be the best you and not the second best someone else.

DESPITE ALL THESE DIFFERENTIATORS, SNOWFLAKES ARE STILL CRYSTALIZED WATER, THE CHOCOLATES ARE STILL SWEET AMALGAMATIONS OF CREAM AND CACAO, AND "YOU" AND "SOMEONE ELSE" ARE STILL PEOPLE. THE VERY FACT THAT WE ARE ALL DIFFERENT IS WHAT MAKES US THE SAME. SO, FIND THE BEAUTY IN DIFFERENCES—PHYSICAL, EMOTIONAL, MENTAL, SITUATIONAL, AND SO ON—RESPECT THE DIVERSE NATURE OF THE HUMAN EXPERIENCE, BUT ALWAYS REMEMBER THAT THOSE DIFFERENCES ARE BORNE FROM THE SAME CLOTH.

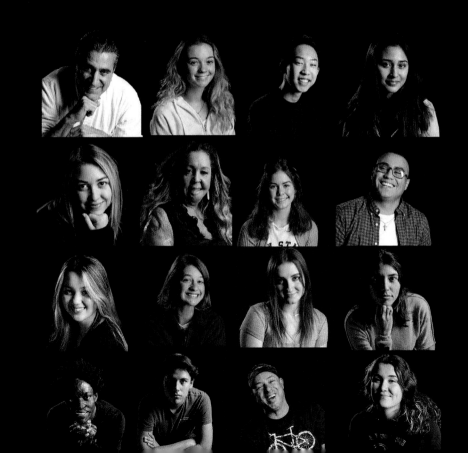

Children's Burn Foundation

For more than 25 years, Children's Burn Foundation (CBF) assists children suffering from severe burn injuries locally, nationally, and internationally. CBF is first to jump in when help is needed and takes a wholistic approach to the recovery of a young burn survivor and the entire family. Services are tailored to the needs of each individual young burn survivor to help each thrive.

The assistance provided includes costly acute care, surgeries to assist with function, burn care not covered by insurance, pressure garments, food vouchers, psychosocial support for the family unit, and transportation for parents to and from the hospital so that they can be at bedside with their children. In addition, CBF provides opportunities for bonding within the burn community including child and family camps, support groups, attending World Burn Congress, and school reentry programs to help newly burned children return to school within an accepting environment.

Children's Burn Foundation reaches more than eighty-five thousand children and families annually through targeted burn prevention programs to help reduce preventable childhood burns.

The CBF Teen Group is one of its kind and provides a caring place where teens can meet each other for support, learn new life skills and find a safe place where they can be themselves. CBF is extremely proud of our teens who are creative, bright, strong, and are exemplary role models. Congratulations to Maren and everyone involved in creating this touching tribute to burn survivors who learn to thrive!

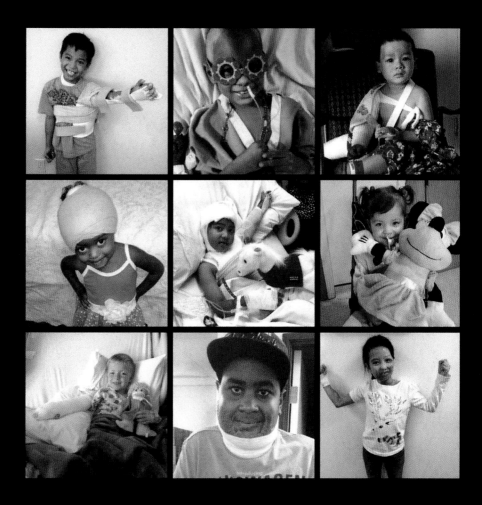

THANK YOU TO ALL OF THE COURAGEOUS BURN THRIVERS
FEATURED IN THIS BOOK. YOUR BEAUTIFUL STORIES WILL
INSPIRE OUR YOUNGEST SURVIVORS TO LEARN TO THRIVE
JUST LIKE YOU.

Acknowledgements

This book would not have been possible without the hard work and dedication of Oaks Christian's Visual Storytelling classes of 2020 and 2021.

-2020 Class -

Carlos Anguiano
Tyler Bartlett
Abbie Beigert
Giselle Farless
Maren Jacobson
Nicole Saurman
Olivia Sletten
Chae Somerville
Eleanor Stonich
Josh Wennes

- 2021 Class -

Skylar Alves
Haley Barney
Madison Brothers
Caleb Holtsnider
Maren Jacobson
Mika Josue
Ty Keough
Preston Loretic
Wancho Luna
Elise Marnell
Nina Mcinery
Carissa Rangel
Justin Staley
Luke Warner
Charlotte White
London Zirretta

Special Thanks To...

Maren Jacobson...............Book's Mastermind

Haley Barney...............Author

Ty Keough...............Book Editor & Layout Design

Elise Marnell & Mika Josue...........Graphic Design

Charlotte White...............Poet

David Hessemer...............Photography Instructor

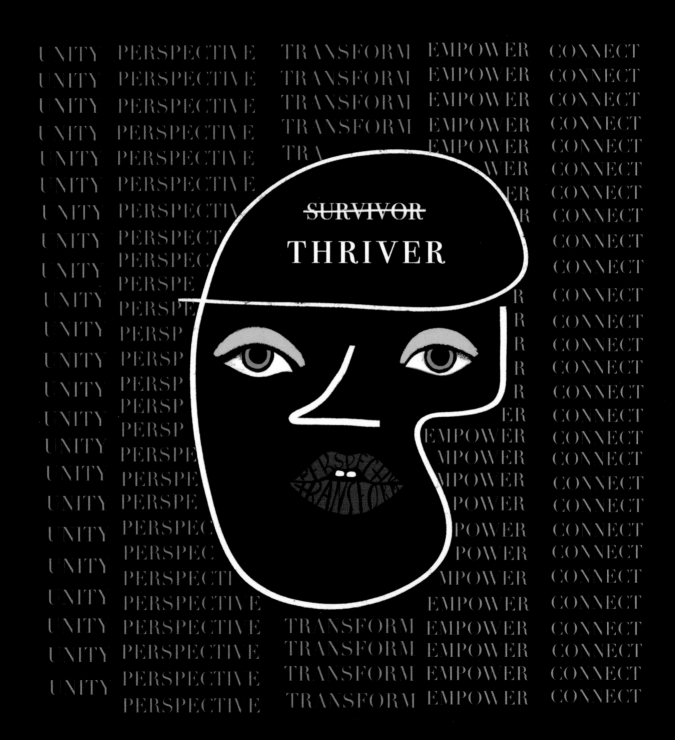